IMAGES
of Aviation

PEARSON FIELD
PIONEERING AVIATION IN
VANCOUVER AND PORTLAND

Historic Pearson Field, now part of the Vancouver National Historic Reserve, is one of the nation's oldest continually operating airfields. For more than a century, this grassy plain has played host to many milestones in aviation history and continues to serve the community. The field was named in honor of Lt. Alexander Pearson Jr., one of the Army Air Service's most promising young pilots, who was killed in 1924. (Washington State Historical Society.)

ON THE COVER: The City of Vancouver, Washington, assumed operation of the commercial side of Pearson Field in 1929. The following year, to showcase the many improvements made, a large air circus was held to celebrate the municipal field's official opening. The committee of civic and aviation leaders in the community, responsible for putting the air circus together, pose alongside an Eaglerock biplane. In the center is Edith Foltz, "Queen of the Air Show" and winner of the dead-stick landing contest. (Clark County Historical Museum.)

IMAGES
of Aviation

PEARSON FIELD
PIONEERING AVIATION IN
VANCOUVER AND PORTLAND

Bill Alley

ARCADIA

Published by Arcadia Publishing
Charleston SC, Chicago IL, Portsmouth NH, San Francisco CA

Printed in the United States of America

Library of Congress Catalog Card Number: 2006921511

For all general information contact Arcadia Publishing at:
Telephone 843-853-2070
Fax 843-853-0044
E-mail sales@arcadiapublishing.com
For customer service and orders:
Toll-Free 1-888-313-2665

Visit us on the Internet at www.arcadiapublishing.com

The decade of the 1920s was the golden age of aviation, and the men and women who took to the skies were the leading celebrities of their day. Parents followed the exploits of the many record-setting pilots in the pages of the nation's newspapers, and their children looked to them as heroes and role models. Around 1925, young Bob Alley is already looking skyward. (Author's collection.)

CONTENTS

ACKNOWLEDGMENTS

I would like to thank the following individuals and organizations, whose contributions made the completion of this volume possible. First, my appreciation to Kyle Kihs and John Nold of the Pearson Air Museum in Vancouver, who granted me unfettered access to all the holdings of their museum; their generosity constitutes the vast majority of the photographs published herein. I would also like to express my gratitude to Garen Horgen of the Vancouver National Historic Reserve Trust, Theresa Langford of the Fort Vancouver National Historic Site, and Dale Denny, who made his personal collection available to me. Finally, I would like to acknowledge the contributions of the Clark County History Museum, the Oregon Historical Society, the Southern Oregon Historical Society, and the City of Vancouver's Pearson Airport manager.

—Bill Alley
Prune Hill, Washington

INTRODUCTION

Situated along the northern bank of the Columbia River, Fort Vancouver's roots go back to its days as a Hudson's Bay Company fur trading post. At the dawn of the 20th century, the Vancouver Barracks, as the post had come to be called, had developed into a bucolic army post complete with its own polo field. On September 19, 1905, however, an event occurred that would ultimately lead to the establishment of one of the nation's landmark pioneer airfields. On that morning, Lincoln Beachey took off in his Baldwin airship from the grounds of the Lewis and Clark Centennial Exposition in Portland with a letter for the commandant at Fort Vancouver. Upon landing on the post's polo field, Beachey had not only completed the first aerial crossing of the Columbia River, he had also set a new airship endurance record and been one of the first to ever deliver a letter by airship.

Vancouver fully entered the aviation age six years later when a few aeronauts began operating their aircraft from the barracks' grounds. The first of these was Silas Christofferson, a race car driver who built a Bleriot-type monoplane in 1911 and began to experiment and tinker with this new machine on the grounds of the barracks. Several attempts were made achieve flight, but Christofferson's monoplane was able to do little more than rise a few feet into the air. The first to successfully fly from the polo grounds was another aviator, Charles "Fred" Walsh, in 1912. Walsh was an experienced flier with the Pacific Aviation Company.

In 1912, Christofferson made headlines with an aerial exhibition during the 1912 Portland Rose Festival with a new airplane, a Curtiss pusher biplane. He had a ramp built on the roof of Portland's Multnomah Hotel where he hoisted his plane up and launched it, soaring over downtown Portland and landing across the river at the barracks 12 minutes later.

Later that same year, aviator Walter Edwards brought airmail to the Pacific Northwest. Using the same plane as Christofferson used to fly off the Multnomah Hotel, Edwards prepared an airmail exhibition from Portland to the field at the Vancouver Barracks. A temporary postal substation was set up at a Portland country club and two flights, on August 10 and 11, carried 5,000 letters, each postmarked "Portland Aviation Station No. 1." Once in Vancouver, the letters were collected by the post office and delivered. Edwards' was not the country's first airmail flight (that having been accomplished the year before in New York state), but it was the first in the Pacific Northwest. The flight also has the distinction of being the first post-office sanctioned interstate airmail flight.

For the next several years, a growing number of local aeronauts continued to experiment with their ships at the Vancouver Barracks, occasionally having to run off a canvas- munching army mule. With American entry in World War I in Europe, however, the usually pastoral airfield would undergo a dramatic transformation.

With the United States fully committed to the war effort, there was a significant demand for the materials needed to build airplanes. Sitka spruce, which was light, flexible, and straight-grained, was ideal for the construction of aircraft frames, and the forests of the Pacific Northwest enjoyed an abundance of such trees. Labor unrest in the forest, however, threatened spruce production. Foremost among the radical labor in the woods was Industrial Workers of the World, more widely

known as the Wobblies, and in the summer of 1917 the entire lumber industry in the Northwest was crippled by a general strike. To ensure uninterrupted production of spruce for the war effort, the United States Army Signal Corps formed the Spruce Production Division and began using soldiers to keep the camps and mills running.

Col. Brice Disque was placed in overall command of the Spruce Division, and he wasted no time in stabilizing the labor situation. He ordered the institution of the eight-hour day, (a major labor demand in the strike), sought to improve working conditions, and paid his soldiers civilian wages. He also began construction of a huge spruce cut-up plant on the site of the aviation camp.

Constructed in a mere 45 days, the Vancouver plant was the largest of its kind in the world. By war's end, it had milled more than 76 million board feet of lumber, most of it earmarked for aircraft production in the United States, England, and France. With the signing of the armistice in November 1918, however, the plant ceased operation and the equipment sold off. Most of the buildings were razed in 1924.

With the end of the war a degree of tranquility returned to the field at the Vancouver Barracks, but a new phase in the airfield's history was in the offing. The war had taught the army the importance of aircraft, and, in order to keep their planes flying and pilots trained, the Army Air Service joined with federal and state forestry officials to begin aerial fire patrols over the region's forests. In 1921, the Army Air Service established a presence at the barracks field, one of several fire patrol bases in the Northwest.

In 1923, the Army Air Service's presence was expanded when the 321st Observation Squadron of reserves was based at the barracks field. Early the following year, Lt. Oakley Kelly was placed in command at the field, and the energetic young flier, holder of an endurance record and the first to complete a nonstop transcontinental flight, would make substantial improvements to the facilities at the field and enthusiastically support expansion of civilian commercial aviation. With the army's facilities located at the western boundary of the field, a fledgling civilian sector, known as the Chamber of Commerce Field, operated at the eastern end.

Shortly after Kelly's arrival, four Douglas biplanes that were the country's entry in a race to be the first to fly around the world visited the Vancouver Barracks field. The planes were en route from the factory in southern California to their starting point in Seattle. Later that year, in September, the world fliers, having successfully completed their historic flight, again stopped in Vancouver on their way south from Seattle.

The 321st Observation Squadron quickly settled in to their routine of training flights, and, under the direction of Lieutenant Kelly, undertook major improvements to the field and its support facilities. By 1925, however, the awkward designation of Vancouver Barracks Aerodrome had fallen out of favor and a new name was sought. The army was asked to rename it Pearson Field in honor of Alexander Pearson, one of the army's brightest young pilots killed the previous year.

Pearson was an army test pilot who held numerous flight records. In 1919, he achieved the fastest time in the Transcontinental Reliability and Endurance Test. Flying a DeHaviland DH-4, Pearson made the round-trip, cross-country flight in 45 hours, 37 minutes, and 16 seconds of actual flying time. In 1921, Pearson became the first to fly into the Grand Canyon while undertaking an aerial survey for the U.S. Department of the Interior, and in 1923 he set a new world speed record of 167.73 miles per hour. He lost his life in 1924 while preparing for the prestigious Pulitzer Trophy Race in Ohio when a wing strut failed and his plane crashed.

Pearson Field was officially dedicated on September 16, 1925. To mark the occasion, Lieutenant Kelly organized a large air show, inviting many of Pearson's friends in the air service to participate. Fifty-six aircraft from across the West converged on Pearson, providing the audience of 20,000 a spectacular show of precision flying, mock bombing runs, races, and parachute drops.

Military flights continued to dominate activity at Pearson field until 1926. Government contracts were being let for regular airmail routes, and in late 1925 Pacific Air Transport (PAT) was awarded the contract to carry mail along the West Coast. A survey of the route resulted in Pearson Field being selected to service the Portland Post Office; airmail service between Seattle and Los Angeles was inaugurated on September 15, 1926.

The aviation records and firsts that marked the early years of flight at the Vancouver Barracks Field would carry into the future at Pearson Field. During the summer of 1928, the Ford Reliability Air Tour stopped at Pearson Field. The following year, on October 18, Pearson Field was party to another aviation milestone when a Soviet-built monoplane, the *Land of the Soviets*, touched down at Pearson Field on its Moscow-to-New York flight. A second Soviet plane would land at Pearson in 1937, placing the field in the world media spotlight, when a Soviet Ant-25 carrying three crew members descended on Pearson Field. This aircraft, with its long, albatross-like wings had set down after completing the first transpolar flight, flying nonstop from Moscow to Pearson Field.

The 1920s also saw a resurgence of civilian aviation at Pearson Field. In 1925, in response to an army regulation prohibiting non-emergency civilian use of its fields, the Vancouver Chamber of Commerce decided to establish a separate commercial field. At the suggestion of Lieutenant Kelly, 70 acres of land adjacent to Pearson were leased from the Spokane, Portland & Seattle Railroad and graded to accommodate the growing number of civilian flights. The chamber of commerce would operate this commercial field until 1928, when the City of Vancouver assumed management. Soon the airmail planes were carrying passengers, and local air services and flying schools were overshadowing the military presence at Pearson. For both military and commercial interests, Pearson Field had become an important regional hub, providing services for planes to and from Seattle to the north, Spokane and Boise to the east, and Medford, Oregon, and California to the south.

For the remainder of the 1930s, the army and civilians continued to share Pearson Field, though a number of concerns, including Pacific Air Transport and the Rankin Flying School would defect to Portland's new Swan Island Airport. The 321st and other visiting squadrons continued to train out of Pearson until the United States entered World War II. As an emergency measure, civilian flying at most West Coast airports was prohibited and the military presence at Pearson was moved to larger facilities. Only a gravel emergency strip was maintained at Pearson during the war, and a few Italian prisoners of war were housed in the old hangar.

Civilian activity returned to Pearson Field at the conclusion of the war. The military declared the field surplus in December 1945, and, under the auspices of the City of Vancouver, the commercial and military fields were officially joined and renamed Pearson Airpark the following year. Actual title to the military field was transferred to the City of Vancouver in 1949. Plagued by financial instability in those early years, the future survival of Pearson Airpark was precarious. To attract business, one of the runways was lengthened and then paved, and new hangars were built.

During the 1960s, conflicts arose between the City of Vancouver and the National Park Service, which was preparing to build a reconstruction of the original Fort Vancouver stockade, which had earlier occupied a portion of the field. In the 1970s, the National Park Service purchased a portion of Pearson Field on the west side, and the City of Vancouver acquired land on the east from the railroad. Eventually another agreement was reached that moved Pearson's hangars and operations away from the stockade. Today the National Park Service, the City of Vancouver, and the Pearson Air Museum (part of the Vancouver National Historic Reserve) cooperate in the preservation and interpretation of all aspects of the Vancouver National Historic Reserve's past.

In 1994, a $3 million grant was awarded by the M. J. Murdock Charitable Trust for the construction of a new museum on the site of the larger military hangar, which had burned down in 1976. Today this modern facility and the adjacent original hangar constitute the Pearson Air Museum's M. J. Murdock Aviation Center, which is dedicated to the preservation of Pearson Field's aviation heritage. Designed to recreate the typical army airfield from the period between the two world wars, the Pearson Air Museum houses numerous historic aircraft and exhibits describing the field's many historic milestones and serves as a venue for educating the community about the region's contributions to aviation.

The airfield itself, its name recently returned to the earlier Pearson Field, continues to serve the community as a general aviation facility. On September 19, 2005, Pearson celebrated the 100th anniversary of the first landing of an airship on the barracks' polo field and entered into its second century as the Pacific Northwest's pioneer airfield.

Lt. Alexander Pearson, for whom Pearson Field would be named, is pictured here *c.* 1919 in a Thomas-Morse Scout. (Pearson Air Museum.)

One

THE AVIATION CAMP

Among the many attractions at the 1905 Lewis and Clark Centennial Exposition in Portland, Oregon, was a regular series of airship flights by Lincoln Beachey (1887–1915). Only 18 years old, Beachey had already earned the reputation as one of the most famed aviators of his day. His departure on the morning of September 19, 1905, seemed routine until the crowds watched as he flew off to the northeast. It was soon announced that the aviator was carrying a letter from Theodore Hardee, a fair official, to the commandant at the Vancouver Barracks, Gen. Constant Williams. His delivery of Hardee's greeting was hailed at the time as the first time an airship had been used to deliver a letter. (Library of Congress.)

Word that Lincoln Beachey had crossed the Columbia River and landed at the Vancouver Barracks in 1905 attracted a crowd of curious onlookers. This stunt constituted the first controlled powered flight in the state of Washington. (Pearson Air Museum.)

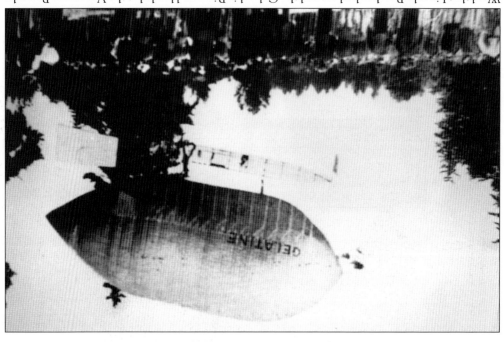

A crowd watches as Lincoln Beachey pilots his Baldwin airship at the 1905 Lewis and Clark Centennial Exposition in Portland, Oregon. (National Archives.)

It took a mere 40 minutes for the young aeronaut to reach the Vancouver Barracks and become the first pilot to land at what would later become Pearson Field, but a change in winds made the return to the Portland fairgrounds more difficult. As his fuel ran low, Beachey decided to land on the farm of A. B. Gilmore, near Orchards, Washington. Although he had been thwarted in his attempt to complete his return trip, Beachey's flight of almost two hours over Clark County was hailed as a new duration record, shattering by 20 minutes the flight of Alberto Santos-Dumont at the Paris Exposition of 1900. (Library of Congress.)

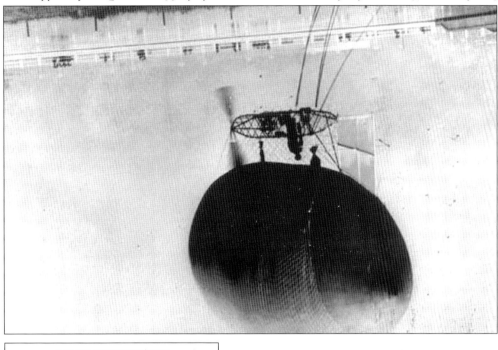

The airship that Lincoln Beachey flew across the Columbia to the Vancouver Barracks was built by Thomas Scott Baldwin (1854–1923) began flying hot air balloons in 1875 and, by the dawn of the new century, began experimenting with the addition of engines to balloons. In 1904, he successfully flew his first motorized dirigible, attracting the attention of the Army Signal Corps. He soon began manufacturing and exhibiting his airships in earnest. This advertisement for Baldwin "Airships, Balloons and Aeroplanes" appeared in the December 1910 issue of *Aeronautics Magazine*. (Pearson Air Museum.)

Lincoln Beachey flies his Baldwin Airship above the Government Building at the 1905 Lewis and Clark Centennial Exposition in Portland. The Government Building occupied a small island in the middle of Guild's Lake and served as the focal point of the exhibition grounds. (Oregon Historical Society, OrHi 11049.)

In 1911, Silas Christofferson of Vancouver built his own Bleriot-type aircraft with a 40-horsepower engine. He experimented extensively with his new airplane but was unable to actually get it off the ground. (Pearson Air Museum.)

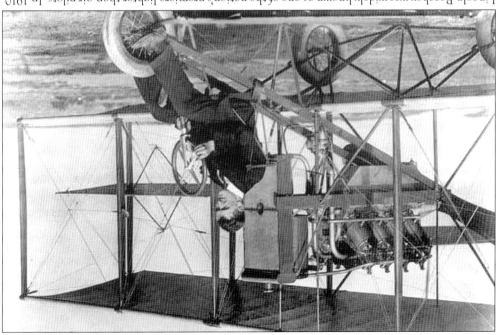

Lincoln Beachey was widely known as one of the nation's premiere lighter-than-air pilots. In 1910, however, he flew for the first time in an airplane and never went back to airships. He quickly mastered the new, heavier-than-air craft, and his exhibitions drew large crowds. He became the first pilot to fly over Niagara Falls, the first to fly a loop, and, in 1911, he set a new altitude record. While performing an exhibition of his skills at San Francisco's Panama-Pacific International Exhibition in 1915, however, Beachey's luck ran out at the age of 28. He was killed when his plane crashed into San Francisco Bay. (Library of Congress.)

Charles "Fred" Walsh was the first to successfully fly an airplane from the aviation camp on June 15, 1912. A crowd was sure to gather any time an aeronaut took to the skies from the aviation camp at Fort Vancouver. (Pearson Air Museum.)

Silas Christofferson is pictured here with his pusher biplane at the Vancouver Barracks around 1912. (Pearson Air Museum.)

Silas Christofferson, like most of the aeronauts of his day, supported his flying by providing rides and instruction. He is pictured here around 1911 with Christy Mathewson, a former baseball pitcher for the New York Giants and Cincinnati Reds. (Pearson Air Museum.)

Louis T. Barrin, a Portland druggist, kept his Burkhart biplane at the barracks field during the summer of 1915. During this period, he was frequently seen in the skies above Vancouver and Portland, and in July raced a number of automobiles at the Rose City Raceway. Barrin was reputedly one of the crew on the NC-1 Flying Boat in its attempt to fly across the Atlantic in 1919. (Oregon Historical Society, CN 000350.)

Silas Christofferson was one of the earliest of aviators who congregated at the Vancouver Barracks around 1911. Although his initial attempts at flight were a disappointment, he would soon be thrilling many with his daring aerobatics. He was killed in San Francisco while flight-testing modifications to his flight controls in 1915. (Pearson Air Museum.)

Pilot Walter Edwards carried some 5,000 pieces of mail on two flights from Portland to Vancouver in August 1912, each postmarked with a special commemorative cancellation. Upon Edwards's arrival at the Vancouver Barracks, the mail was collected by the local postmaster and placed in the regular mail for delivery. This was the nation's first official interstate airmail flight. (Vancouver National Historic Reserve Trust.)

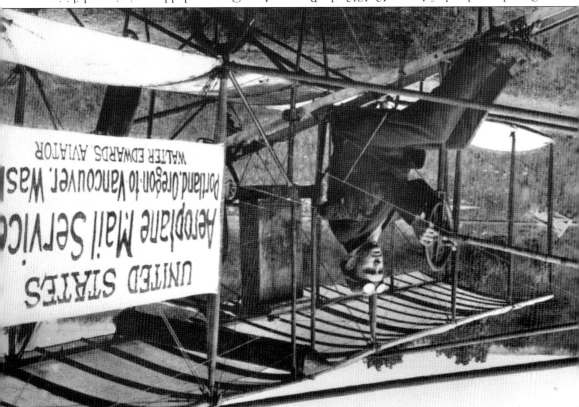

Over the weekend of August 10, 1912, the Bennett Auto Company held an aviation exhibition at the Portland County Club racetrack. In addition to the expected stunts, aerobatics, and a game of aerial baseball, the exhibition featured two airmail flights, the first in the Northwest sanctioned by the post office department. The first flight, on August 10, was also the nation's first interstate airmail flight. The pilot, Walter Edwards, made the flights in the same Curtiss pusher plane Silas Christofferson had flown off the Multnomah Hotel two months earlier. (Vancouver National Historic Reserve Trust.)

Silas Christofferson planned a spectacular aviation stunt for the 1912 Rose Festival in Portland. A 170-foot-long plank platform was built on the roof of Portland's Multnomah Hotel and the young pilot announced that he would fly his Curtiss pusher plane off it. The plane was flown to a Portland golf course and disassembled before being hoisted to the hotel's roof; this was the first crossing of the Columbia River by an airplane. (Pearson Air Museum.)

A platform of boards was constructed on the roof of the Multnomah Hotel to serve as a makeshift runway for Christofferson's takeoff. (Pearson Air Museum.)

An estimated 50,000 spectators gathered on nearby rooftops and on the streets below to watch Christofferson's stunt, many undoubtedly expecting to witness a disaster. Newsreel cameras were on hand to record the event. (Pearson Air Museum.)

Spectators cheer as Silas Christofferson takes to the air from the roof of the Multnomah Hotel, bound for the flying field at the Vancouver Barracks. (Oregon Historical Society, OrHi 24278.)

Silas Christofferson soars over downtown Portland on his 12-minute flight to the Aviation Camp at the Fort Vancouver Barracks. To the right, the nearly completed Steel Bridge rises over the Willamette River. (Pearson Air Museum.)

One of Silas Christofferson's more popular exhibition stunts was to break balloons floating 18 inches off the ground with his Curtiss pusher plane. (Oregon Historical Society, OrHi 63840.)

Two
SPRUCE WILL
WIN THE WAR

The vast stands of timber in the Pacific Northwest were an important strategic commodity. The old-growth spruce trees, with their tight, straight, and flexible grain, were an essential component in manufacturing airplanes. With posters such as these, the new Spruce Production Division stressed the patriotic value of timber workers. (Vancouver National Historic Reserve Trust.)

New Poster of Spruce Production Division
Designed by a Signal Corps Soldier

Soldier labor was used to build and operate the spruce plant. Under the supervision of H. S. Mitchell, an Oregon lumberman, construction was completed in a remarkable 45 days. (National Archives.)

The Vancouver Cut-Up Mill was officially dedicated on February 17, 1918. The ceremonies, by invitation only to comply with government regulations, drew a crowd of more than 6,000. (National Archives.)

Soldiers from the Signal Corps' Aviation Section raise the new pennant with the emblem of the Spruce Production Division during the dedication of the Vancouver Spruce Cut-Up Plant on February 7, 1918. (National Archives.)

The lumber produced at the plant was intended for aircraft production in American and allied factories. Because the lumber would be shipped direct to those factories, it was generally milled to the manufacturer's specifications. An estimated 30 percent of the lumber produced was unsuited for aircraft use and was sold for other purposes. (National Archives.)

Rived, or split, cants of spruce were shipped by rail from logging camps throughout the Pacific Northwest and delivered to the mill at Vancouver. The cants were stacked by the railroad sidings until ready for milling. (National Archives.)

The principal officers of the spruce cut-up plant confer in front of some rived cants of spruce in February 1918. Pictured, from left to right, are H. S. Mitchell, the man who built the mill, Maj. John B. Reardon, the mill's commanding officer, Lt. Henry L. Dickinson, the technical officer, Lt. T. B. Lawrence, adjutant, and Capt. O. P. M. Goss, the assistant general manager. (National Archives.)

Steam cranes were used to unload the spruce cants and cut lumber from railroad cars. Between 35 and 40 railcars of spruce arrived at the plant each day from Spruce Division camps and mills in the woods of Washington and Oregon. (National Archives.)

Soldiers of the Spruce Division move large slabs of spruce into the mill. The main building, 358 by 288 feet, was divided into six units, each a small sawmill unto itself. (National Archives.)

This photograph of the interior of the Vancouver Spruce Cut-Up Plant gives an idea of the immensity of the operation. (National Archives.)

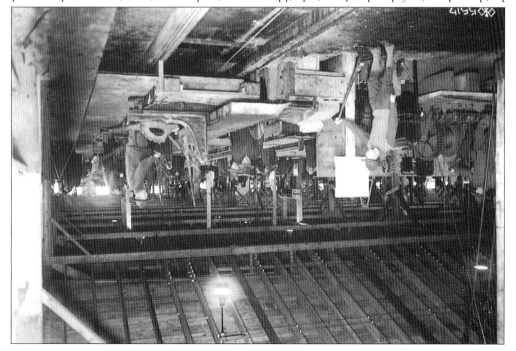

Inside each unit of the plant's main building were circular-saw rigs, trim saws, edgers, and re-saws, all operated by soldiers of the Spruce Division. By war's end, 76,653,429 board feet of lumber, primarily spruce but also cedar and fir, passed through the Vancouver Cut-Up Plant. (National Archives.)

These men are hard at work at the blacksmith shop at the Vancouver Spruce Cut-Up Plant. (National Archives.)

Immediately following the armistice ending the Great War in Europe, the spruce cut-up plant in Vancouver was shut down. This cartoon from the December 21, 1918 issue, of the *Straight Grain*, the post's official newspaper, echoed the sentiments of the soldiers at the plant as they were discharged and sent home. (Vancouver National Historic Reserve Trust.)

STRAIGHT GRAIN

SO LONG, OLD MILL! WE'VE DONE OUR STRETCH.

Many of the troops employed at the Vancouver Cut-Up Plant were housed in tents erected in-between the plant's more substantial buildings. (National Archives.)

Three

ALEXANDER PEARSON

Alexander Pearson was born in Sterling, Kansas, on November 12, 1895. He later attended the University of Oregon in Eugene and with American entry into the Great War in 1917 entered the Army Air Service. By the time he had completed his flight training, however, the armistice had already been signed. (Pearson Air Museum.)

Pearson made national headlines in the fall of 1919 as an entrant in the Army Air Service's Transcontinental Reliability and Endurance Test, a grueling round-trip, cross-county flight attempted by 63 army planes. Alexander Pearson and his mechanic, Sgt. Royal Atkinson, completed the flight with the best actual flying time of 47 hours, 37 minutes, and 16 seconds. (Pearson Air Museum.)

One of Pearson's earliest assignments was to fly as a scout for the Army's 1919 transcontinental truck convoy as it passed through Missouri and Kansas. The glamour of flight was seen as a useful recruiting tool for the air service, as evidenced by the advertisements painted on the fuselage of many aircraft. A number of pigs pictured here take advantage of the shade offered by Pearson's plane in a Kansas field. (Pearson Air Museum.)

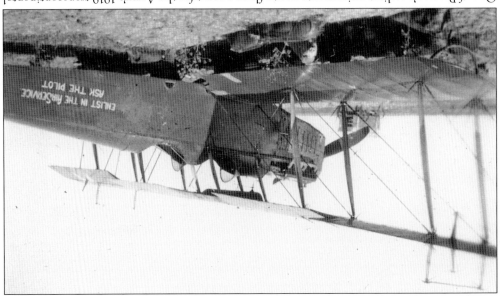

The Grand Canyon aerial survey, conducted by Lieutenant Pearson in 1922, attracted national media attention. The Fox Newsreels sent cameraman Blaine Walker to film the event. The first aerial motion pictures of the Grand Canyon were taken by mounting the Fox camera onto the gun mount of Pearson's DH-4, with Pearson's mechanic, Sgt. Arthur Juengling, turning the crank. (Pearson Air Museum.)

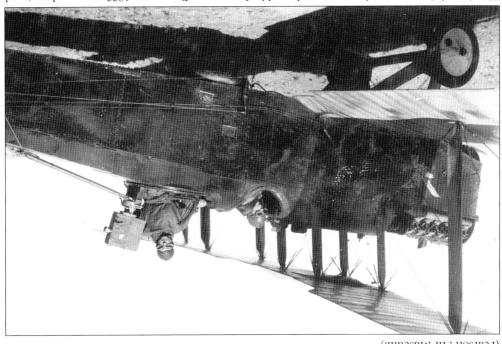

Pearson was given another opportunity to set a new record in 1921. He was selected to attempt the first transcontinental flight in less than 24 hours. Unfortunately, Pearson's newly installed engine failed on the way to the starting point in Florida, and he was lost for six days in a desolate region of northern Mexico. His specially modified DH-4, pictured here, had the front pilot's seat replaced with extra fuel and oil tanks and the controls moved into the rear observer's seat. (Pearson Air Museum.)

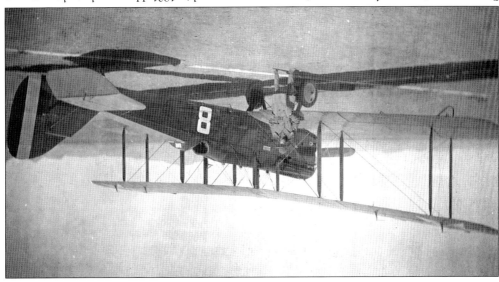

When the U.S. Department of the Interior sought the army's assistance in surveying the air currents in and around the Grand Canyon National Park in the summer of 1922, Alexander Pearson was selected for the task. Conventional wisdom of the time held that the canyon was unsuited for flying, but Pearson's survey proved otherwise. His survey paved the way for all future "flight seeing" trips at the national park, and in the process he became the fist person to fly within the Grand Canyon itself. "Mechanician" Arthur Juengling and Pearson pose by the DH-4 at Fort Bliss, Texas, just before their departure for the Grand Canyon. (Pearson Air Museum.)

Pearson set another speed record on July 2, 1922, when he and Sgt. E. F. Nendell took off from El Paso's Fort Bliss on a flight to Portland, Oregon, where they both had family. The purpose of the flight was to chart new air routes, scout potential locations for airfields, and establish the feasibility of defending the West Coast with planes stationed along the southern border. Pearson's record 16 hours flight time reinforced his reputation as one of the army's swiftest pilots. He is pictured here at a private airstrip in Portland's Eastmoreland District. (Pearson Air Museum.)

Sgt. E. F. Nendell and Lt. Alexander Pearson smile for the camera in Portland in July 1922. Ironically, this is the closet Pearson ever came to the field that would later bear his name. (Pearson Air Museum.)

It must have been a dream come true for Pearson when he was transferred to the Engineering school at McCook Field near Dayton, Ohio, at the close of 1922. McCook was the center of aviation innovation and experimentation at the time and home to some of the army's most talented pilots. (Pearson Air Museum.)

After completing the yearlong Engineering school, Pearson was made a member of the test pilot corps at McCook. He reveled in finding himself at the forefront of aviation design and was involved in testing many new innovations. Most importantly, he was quickly recognized as one of the fastest and most precise fliers among the air service's best. Pearson, fifth from the right, poses with the other test pilots by a DH-4; second from the right is Jimmy Doolittle; and on the right is John Macready. (Pearson Air Museum.)

WORLD'S OFFICIAL SPEED RECORD
F.A.I.
for
500 KILOMETERS at 167.73 M.P.H.

Lt. ALEX PEARSON Jr.

VERVILLE SPERRY R-3 RACER

On March 31, 1923, Pearson entered a 500-kilometer speed race at Wilbur Wright Field (now Wright-Patterson Air Force Base). Flying a Verville-Sperry monoplane over a 10-lap course, with Orville Wright as an official observer, Pearson set a new world speed record of 167.73 miles per hour, wresting the title from a French pilot. (Pearson Air Museum.)

Alexander Pearson poses by the Verville-Sperry R-3 racer at the International Air Races in St. Louis, Missouri, in October 1923. This was the same airplane Pearson had set the world record with, but now included several modifications such as low-drag radiators and an innovative metal propeller. A last-minute ruling, however, forced him to replace the new propeller with a wooden one. Pearson was forced to drop out of the 1923 Pulitzer Race because the change resulted in an unbalanced propeller. The newly installed, low-drag radiators are clearly visible on the R-3's wing. (Pearson Air Museum.)

In 1924, Lieutenant Pearson again was selected to fly in the Pulitzer Trophy Race, reserved for the nation's fastest planes and pilots. He would pilot the Navy Curtiss racer that was acquired by the army and designated the R-8. Described as "the swiftest device ever created by the genius of man" by the media, the R-8, with Pearson at the controls, was the odds-on favorite to win. During a practice flight, however, one of the plane's struts failed and the R-8 crashed into the ground at an estimated 260 miles per hour. Lieutenant Pearson was killed instantly. (Pearson Air Museum.)

Alexander Pearson sits in the cockpit of the R-8. During a practice flight on September 3, 1924, the hollow wing strut gave way under the extreme pressures of Pearson pulling out of a dive at 260 miles per hour. The wings collapsed, and Pearson's plane plunged to the ground. Pearson was killed instantly on impact. (Pearson Air Museum.)

Pearson's tragic and untimely death was a blow to both the air service and his family. His record of achievement during his short career as an army pilot was recognized with his burial in Arlington National Cemetery. (Pearson Air Museum.)

GENERAL ORDERS,
No. 9.

WAR DEPARTMENT,

WASHINGTON, MAY 7, 1925.

* * * * * * *

III - Designation of flying field.
The landing field at Vancouver Barracks, Wash.,
is designated as
" PEARSON FIELD,"
in honor of
First Lieutenant Alexander Pearson, Jr.,

who was killed in an airplane accident
September 2, 1924,
at Fairfield, Ohio.
[A.G. 680-9 (2-16-25)]

* * * * * * *

BY ORDER OF THE SECRETARY OF WAR:

J. L. HINES
MAJOR GENERAL,
CHIEF OF STAFF.

OFFICIAL:

ROBERT C. DAVIS
MAJOR GENERAL,
THE ADJUTANT GENERAL.

On May 7, 1925, the War Department issued General Order Number 9, changing the name of the Vancouver Barracks Aerodrome to Pearson Field in honor of Lt. Alexander Pearson. Several fields had sought to be named for the late pilot, but the proximity of Pearson's parents in Portland, and perhaps the lobbying efforts of Lt. Oakley Kelley, ensured that the field at Vancouver would be selected. (Pearson Air Museum.)

An estimated 20,000 spectators were on hand for the dedication ceremonies and air circus at the newly dedicated Pearson Field, including most of Vancouver's schoolchildren, as the day was declared a school holiday. (Pearson Air Museum.)

OFFICIAL
15c PROGRAM 15c
DEDICATION of PEARSON FIELD
Wed. Sept. 16, 1925 Vancouver Barracks, Wash.

US.ARI

Pendleton Round-Up
Sept. 16, 17, 18, 19, 1925
"Epic Drama of the West"

Boeing Airplane Company

Manufactures of

Military and Commercial
Aircraft

SEATTLE, - - - WASHINGTON

Washington Printing Co., 106 W. Fifth St., Vancouver, Wash.

The dedication of the newly named Pearson Field was accompanied by one of the largest air circuses the country had seen. More than 50 planes from across the west entertained the crowd of 20,000 with races, mock battles, bombing runs, and parachute drops. The Boeing Aircraft Company underwrote the cost of printing the official program, which carried the details of all of the day's events. (Pearson Air Museum.)

This photograph is an aerial view of the 50 aircraft lined up at the dedication of Pearson Field on September 16, 1925. (Pearson Air Museum.)

Four

THE MILITARY FIELD

A row of Curtiss JN-4 "Jenny" aircraft lined up on the field of the Vancouver Barracks around 1923. The ubiquitous "Jenny" was the most prevalent of the aircraft sold as surplus after the war and was popular with many early barnstormers. Many also remained in Army Air Service inventories throughout the early 1920s until replaced with more modern equipment.

Soldiers at the Vancouver Barracks Aerodrome work on a surplus Curtiss JN-4 "Jenny," *c.* 1923. (Vancouver National Historic Reserve Trust.)

An Army Air Service Thomas-Morse Scout sits at the Vancouver Barracks airfield around 1919. Nicknamed the "Tommy" by army pilots, the Scout was a widely used single-seat pursuit trainer during and after World War I. (Pearson Air Museum.)

Before he was assigned command of the 321st Observation Squadron, Oakley Kelly (left) made headlines in the spring of 1923 when he, accompanied by Lt. John Macready (right), made the first nonstop transcontinental flight. They made their historic trip in a specially modified Fokker T-2 monoplane. In this photograph, the two pilots pose with their aircraft and the large amount of fuel and oil required for their flight. (Pearson Air Museum.)

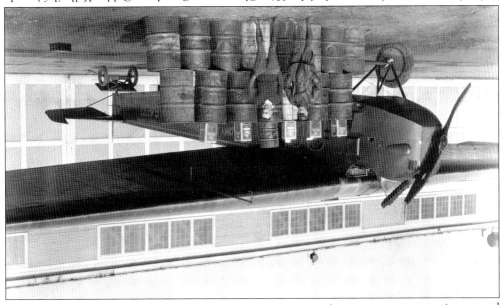

Oakley Kelly commanded the 321st Observation Squadron from 1924 through 1928. When he wasn't busy with his official duties, or working tirelessly to expand and promote the military and commercial activities at Pearson Field, he obviously found time to indulge in one of his favorite pastimes. (Pearson Air Museum.)

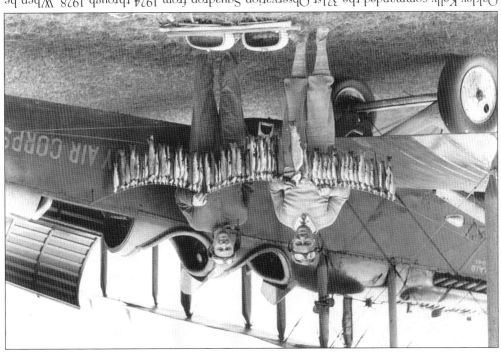

Members of the 321st Observation Squadron Reserves pose in front of one of their DeHaviland DH-4 aircraft in 1926. Seated are the enlisted men who ensured that the aircraft remained airworthy, and behind them stand the reserve pilot officers who regularly trained at Pearson Field. (Pearson Air Museum.)

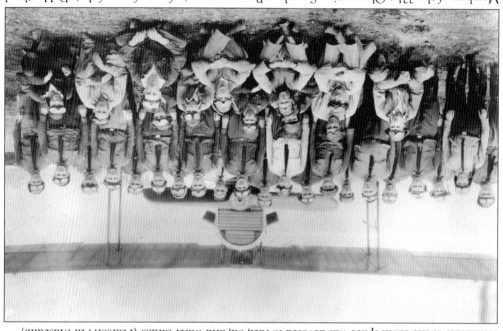

The Fokker T-2, piloted by Oakley Kelly and John Macready, required extensive modifications. The pilot sat in front alongside the engine, and to access the main cabin the seat had to be folded down. A second set of flight controls, visible through the side door, was placed inside the cabin. The remainder of the cabin space was devoted to fuel, oil, and water tanks. (Pearson Air Museum.)

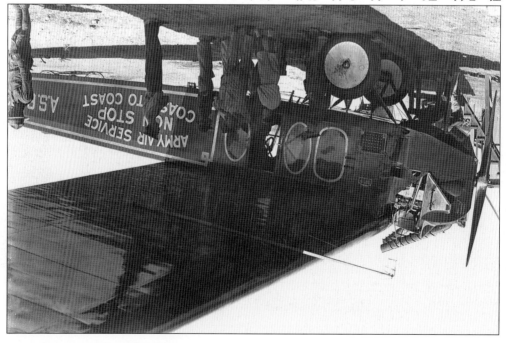

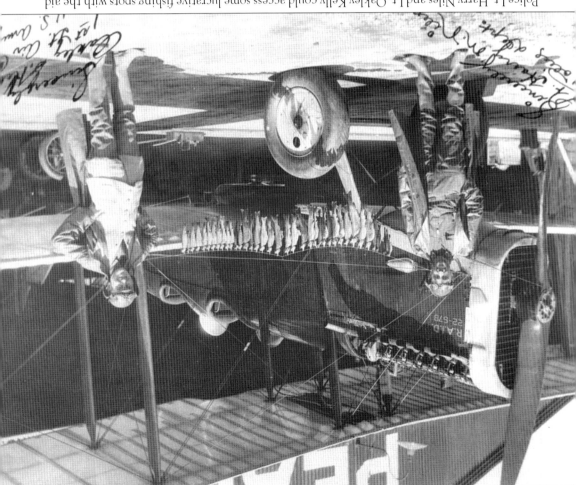

Police Lt. Harry Niles and Lt. Oakley Kelly could access some lucrative fishing spots with the aid of Kelly's DeHaviland DH-4. (Pearson Air Museum.)

In 1924, several teams from different countries vied to become the first to fly around the world. The Army Air Service team consisted of eight men in four Douglas aircraft. On their way to their departure point in Seattle, the army's 'Round the World fliers made a stop a Pearson Field. The following October, the remaining members of the successful American team again stopped over at Pearson on their way back to Los Angeles. (Pearson Air Museum.)

The Douglas World Cruiser *Chicago* is admired at Pearson Field in 1924, one of four large Douglas aircraft built for the 'Round the World flight. Each was named for an American city. The *Chicago* was piloted by Lts. Lowell Smith and Leslie Arnold. (Pearson Air Museum.)

One of the Douglas World Cruisers at Pearson Field in 1924. This photograph might have been taken before the beginning of their world flight, as the plane's name has not yet been painted on the engine cowling. (Pearson Air Museum.)

Members of the army's team of World Fliers pose bedside on of their ships. Pictured, from left to right, are Lowell Smith, Frederick Martin, unidentified, Leigh Wade, Leslie Arnold, Henry Ogden, and Sergeant Turner. (Pearson Air Museum.)

Three Curtiss JN-4 "Jennies" are parked by the military hangars at Pearson Field in 1926. The Army Air Service began as the aviation section of the Army Signal Corps and became the Army Air Service in 1917. In 1926, the Army Air Service became the Army Air Corps. Behind the hangar on the right is the Pacific Air Transport facility, where the first West Coast airmail was handled. (Clark County Historical Museum, P.08.3b.)

The 489th Bomber Squadron Reserves, based at Seattle's Sand Point field, came to Pearson Field for their annual summer training in July 1931. Approximately 20 officers arrived in 12 planes from their base in Seattle. To augment their training, a giant B-2 Curtiss Condor was dispatched from Rockwell Field in San Diego. (Clark County Historical Museum, P08.4.4.)

The Condor carried a crew of five and towered over the other aircraft on the field. In addition to the pilot and copilot, there was a bombardier/gunner in the nose and two machine gunners in special gun wells on the wings behind the engines. A telephone system allowed the crew to communicate with each other. (Dale Denny collection.)

The two crewmen standing beside the Curtiss B-2 Condor as they visit Pearson Field give an indication of the immensity of the plane. Twelve Condors were built in 1929 and 1930, but advances in aviation technology soon made this fabric-covered bomber obsolete. It was out of service by 1934. (Pearson Air Museum.)

A Boeing P-12 is parked outside the Pearson Field hangar. The P-12 was one of the most widely distributed pursuit aircraft during the interwar years. Approximately 600 were manufactured by Boeing between 1928 and 1932 for delivery to the army and navy. (Pearson Air Museum.)

A squadron of Boeing P-12 pursuit planes visits Pearson Field around 1930. (Pearson Air Museum.)

Pictured here is an aerial view of Pearson Field during the visit of the 20th Pursuit Squadron on June 8, 1931. The headquarters building to the left of the rows of planes and the smaller of the two hangars were originally built in 1918 as part of the spruce mill. Both are now part of the Pearson Air Museum. (Pearson Air Museum.)

The arrival of a visiting squadron at Pearson Field was sure to bring out a number of visitors to the field. These pursuit planes, possibly from the 20th Pursuit Squadron, have attracted a small crowd. When the 20th Pursuit Squadron, a regular visitor to Pearson Field, arrived in the summer of 1932, the pursuit planes left for a day's training by conducting a surprise mock attack on Camp Lewis near Tacoma. (Pearson Air Museum.)

A Ford Tri-motor, used as a transport by the Army Air Corps, makes a stop at Pearson Field. A plane such as this accompanied the 489th Bomber Squadron during its visit in July 1931. (Pearson Air Museum.)

The arrival of any visiting squadron was sure to attract a number of visitors to Pearson Field. Automobiles are seen here at the side of the road as their occupants study the neat rows of pursuit planes and their accompanying transports. (Dale Denny collection.)

A Consolidated PT-1 sits in the fog at Pearson Field. The PT-1 was the Army Air Service's first primary trainer built after World War I, introduced into service in 1925. Built with a welded chrome steel frame, the PT-1 proved so sturdy and reliable that it quickly earned the nickname "Trusty." To prevent the engine from overheating it was not uncommon for the planes to be flown without their cowlings. (Dale Denny collection.)

An unidentified group of men welcome a bleary-eyed army pilot and his DH-4 at Pearson Field *c.* 1925. (Pearson Air Museum.)

The 20th Pursuit Group of the Army Air Corps, comprising of Boeing P-12 aircraft, made regular visits to Pearson Field in June 1931. The squadron was based at Mather Field in Sacramento. The planes with the swastika insignia were assigned to the 120th Squadron of the Colorado National Guard. (Pearson Air Museum.)

An unidentified group of fliers poses at Pearson Field around 1930. These men could be members of the 321st Observation Squadron or members of any of the many other army units that called regularly at Pearson in the years between the wars. (Pearson Air Museum.)

A quiet day at Pearson Field was one of general maintenance and other routine duties. The small hangar on the right was built in 1918 as part of the spruce mill and moved c. 1921 to its present location, where it still stands, as arguably the oldest aircraft hangar still in use in the United States. The newer hangar on the left burned down in 1976. (Dale Denny collection.)

A Boeing P-26 "Peashooter" is rolled out of the hanger at Pearson Field around 1934. The P-26 was the first all-metal monoplane fighter produced for the Army Air Corps. (Pearson Air Museum.)

Lt. Carlton Bond assumed command of the 321st Observation Squadron in 1929 and served until his transfer in 1933. He returned to this posting as a captain in 1938, serving until 1940. (Pearson Air Museum.)

The new Boeing YB-9 visited Pearson Field around 1931. The YB-9 was the first all-metal bomber designed for the Army Air Corps and featured a cantilever-supported single wing. Some earlier design components lingered, however, with the pilot and crew still sitting in open cockpits. (Pearson Air Museum.)

Flying the YB-9 was Maj. Eric Nelson, one of the army's 1924 World Fliers. This sleek new plane was based on a new design introduced by the Boeing Monomail. Powered by two 600-horsepower engines, the YB-9 was as fast as many of the pursuit planes of its day. (Dale Denny collection.)

Douglas O-38 aircraft from Pearson Field's 321st Observation Squadron pass over Mount Hood on maneuvers *c*. 1928. (Pearson Air Museum.)

Al Davis and Lt. Carlton Bond stand in front of the Pearson Field hangar.

This unidentified group of young ladies paid a visit to Pearson Field in the latter half of the 1920s. (Pearson Air Museum.)

A group of Boeing P-12 pursuit planes, described by the local paper as "lightning fast single seat fighters," warm up their engines at Pearson Field. Behind them the support ships, Ford Tri-motors, can be seen. A squadron such as this stopped at Pearson in the spring of 1931 on its way from the Boeing plant in Seattle to their final delivery point. (Dale Denny collection.)

The Fairchild F-1 was the Army Air Corps's first plane to be dedicated specifically for photographic reconnaissance. This plane, based at Crissy Field in San Francisco, visited Pearson Field in August 1930. It was piloted by former Pearson Field Comdr. Oakley Kelly and Lt. E. B. Bobzien of the Crissy Field Photographic Squadron. (Pearson Air Museum.)

Pictured on the runway is a rare glimpse of a Ford Tri-motor transport at Pearson Field. (Dale Denny collection.)

Pearson's facilities received an upgrade with the addition of a field service tank truck around 1930. The truck carried aviation fuel, motor oil, and water, as well as three modern carbon dioxide fire extinguishers. Pictured, from left to right, are Lt. H. A. Reynolds, Bill Winston, Lt. Carlton Bond, Sgt. Charles Carnes, Howard Sonn, A. H. Clark, Sgt. L. C. Turner, Sgt. Milton Eggen, and R. Spenser. (Clark County History Museum, P8.4.8.)

Aircrews relax beside their air corps transport planes at Pearson Field around 1932. Two of the aircraft are Ford Tri-motors and the other two are Fokker C-14s. The American-built C-14 was the military version of Fokker's single-engine, parasol-winged commercial transport, introduced in 1931. These planes are probably the support contingent for a visiting squadron. (Dale Denny collection.)

Members of the 321st Observation Squadron, based at Pearson Field, pose during annual maneuvers in the summer of 1933. Pictured from left to right, are (first row) Capt. W. Neel, Lt. Reginald Bowles, Lt. H. A. Reynolds, Capt. Sumner Palmer, Capt. James Clark, Lt. Walter Hazelwood, Capt. R. Hossback, Lt. Sidney Murphy, and Lt. C. J. Jensen; and (second row) Capt. Lawrence Hickam, Maj. Howard French (commanding officer), Lt. Howard McCulloch, Lt. Louis Cleaver, Capt. E. R. Farley, unidentified, Lt. Carlton Bond (base commander), Lt. Emil Kennedy, Maj. William Mitchell (flight surgeon), and Capt. Cecil Ross (reserve flight surgeon). (Clark County Historical Museum, P.0008.004.9.)

This North American Aviation BT-9 "Yale" bears the markings of Pearson Field's 321st Observation Squadron. The BT-9 was a basic trainer first introduced in 1936 and the first monoplane used by the squadron. (Pearson Air Museum.)

A Douglass B-18 lands at Pearson Field *c.* 1937. The B-18 "Bolo" was adapted from the commercial DC-2 and was delivered to the Army Air Corps in 1937. This particular airplane is most likely from the 7th Bombardment Group at Hamilton Field in California's Marin County. This was the first unit to fly the new B-18s. (Dale Denny collection.)

Five

THE RUSSIANS
ARE COMING

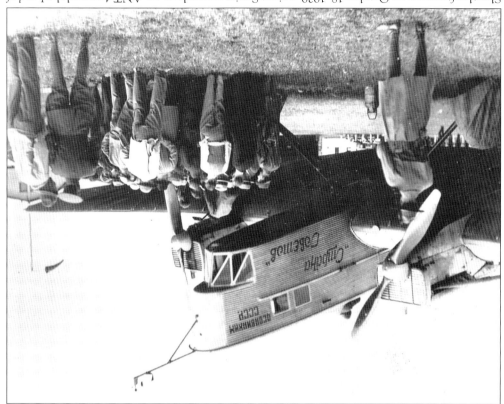

Shortly after noon on October 18, 1929, a giant Soviet monoplane, an ANT-4 named the *Land of the Soviets*, made an unscheduled landing at Pearson Field in order to repair a malfunctioning oil pump on its port engine. The huge all-metal monoplane was in the midst of a landmark Moscow to New York flight when the engine trouble occurred. (Pearson Air Museum.)

The pump on the *Land of the Soviets* was repaired with the assistance of mechanics at Pearson Field and the Russians continued on their way the following morning. (Pearson Air Museum.)

The crew of the ANT-4 selected Pearson Field over the new Swan Island Airport in Portland, preferring to land at a military base. Vancouver's boosters hailed this decision as proof of Pearson's superiority. (Pearson Air Museum.)

The Soviet ANT-4 that landed at Pearson Field drew many curious onlookers from Vancouver and Portland. Its unfamiliar angular lines and the all-metal, single-wing design was a far cry from American designs, which still tended toward wood and fabric biplanes. Shortly after its landing, a large crowd gathered and guards from the Vancouver Barracks were called out to hold them back. Since the plane was too large for any of Pearson's hangars, the guards had to stand watch all night. (Pearson Air Museum.)

With the completion of the repairs to the *Land of the Soviets*, the plane resumed its trip southward to San Francisco before venturing east to New York City. (Pearson Air Museum.)

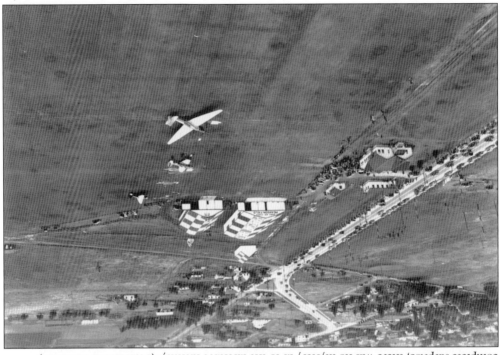

For the past several days, people around the world had anxiously followed its progress as the Soviet ANT-25 and its crew sought to be the first to cross the North Pole from Moscow to San Francisco. A sudden drop in the Soviet plane's oil pressure forced the pilot to end his historic flight at Pearson Field. (Pearson Air Museum.)

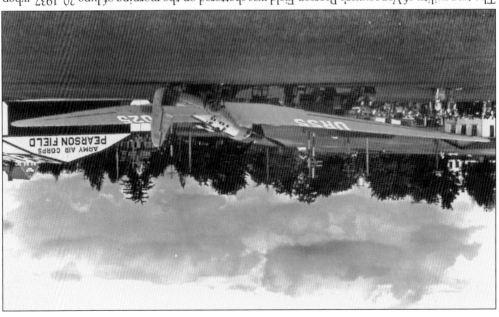

The tranquility of Vancouver's Pearson Field was shattered on the morning of June 20, 1937, when an unfamiliar-looking aircraft, with long red, albatross-like wings, passed over the field in preparation for an unscheduled and unexpected landing. And while its arrival at Pearson Field had come as a complete surprise, there was no mystery as to the aircraft's identity. (Pearson Air Museum.)

South of Eugene, Oregon, the ANT-25 developed a problem with its fuel pump, so the crew decided to turn back to Portland for their landing. As the plane broke through the clouds and rain over Portland's Swan Island Airfield, however, the Russians were surprised to find huge numbers of cheering spectators waiting below. Remembering how the Paris crowds had literally torn Charles Lindberg's plane apart, Chkalov ordered his copilot, "Let's not land here! They will take the aircraft apart for souvenirs. Let's go to the other shore," indicating the military airport in Vancouver marked on his map. (Pearson Air Museum.)

The crowds of curious onlookers are held back by barracks troops while army and municipal leaders inspect the ANT-25 after the three Soviet fliers were whisked off to the home of Gen. George C. Marshall, commandant of the Vancouver Barracks. Tarps were spread out over the cockpit to keep out the drizzle. (Dale Denny collection.)

The three Soviet Transpolar fliers, shortly after landing at Pearson Field, appear pleased with the successful completion of their historic flight. Pictured, from left to right, are navigator Alexander Belyakof, pilot Valery Chkalov, and copilot Georgy Baidukov. (Pearson Air Museum.)

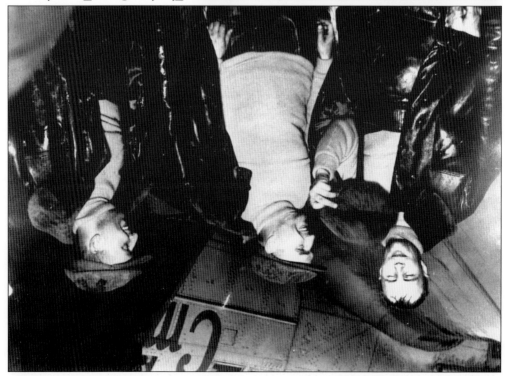

In order to authenticate the historic transpolar flight, three sealed barographs were installed to record the ANT-25's altitude. Chkalov is picture here presenting the barograph to Harry Coffey as evidence that there had been no intervening stops. Coffey was the official representative of the Federation Aeronautique Internationale, the organization responsible for certifying all aviation world records. (Pearson Air Museum.)

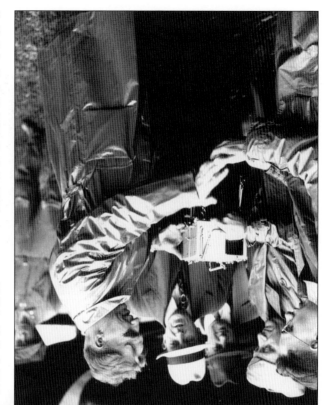

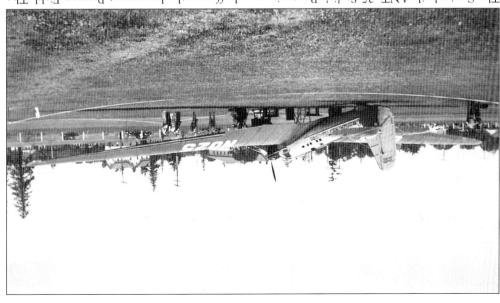

The Soviet built ANT-25 *Stalin's Route* sits roped off near the hangars at Pearson Field. The three fliers, who had been welcomed as heroes, had been whisked away for a series of events in Vancouver and Portland before boarding a commercial flight east. They were greeted in Washington, D.C, by President Franklin Roosevelt, and feted with a parade in New York City. (Pearson Air Museum.)

The Soviet-built aircraft, an ANT-25 designed by Alexi Tupolev, completed the dangerous transpolar flight in 63 hours and 16 minutes. The intended destination was San Francisco, but the failure of a fuel pump forced the fliers to divert to Pearson Field. After landing, it was determined that the Soviet plane had a mere 11 gallons of fuel remaining. (Dale Denny collection.)

Eventually the bulk of the crowds returned to their homes, leaving the giant Soviet monoplane roped off with a few guards and base personnel. Under the supervision of Soviet engineer Vassily Berdnick, pictured here, "Dad" Bacon and Danny Grecco were hired to dismantle the ANT-25 for shipment back to the Soviet Union. (Dale Denny collection.)

The ANT-25 carried three barographs in order to validate the nonstop polar flight. The first was officially presented to an official of the International Aeronautical Federation. Pilot Chkalov holds the other two. (Dale Denny collection.)

The three Soviet fliers were warmly welcomed by the citizens of Vancouver and were provided with new suits from a local haberdasher. The crew was taken to Barracks Comdr. Gen. George C. Marshall's house for a much needed rest and some entertainment. Pictured here, from left to right, are Georgy Baidakov, Soviet Ambassador Aleksandr A. Troyanovsky (the first Soviet ambassador to the United States), General Marshall, Valery Chkalov, and Alexander Belyakov enjoying a light moment in General Marshall's parlor. (Pearson Air Museum.)

Within minutes after the arrival of the transpolar fliers, a large crowd gathered at Pearson Field. Army guards were quickly posted to protect the aircraft, and for the remainder of the day there was a steady stream of automobiles crossing the Interstate Bridge from Portland to see the famous aircraft. (Pearson Air Museum.)

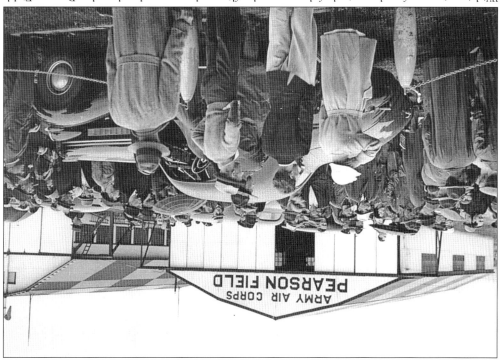

Several months after the Chkalov flight, a group of Vancouver citizens hit upon the idea of erecting a monument commemorating the historic transpolar flight. A "Moscow to Vancouver" committee was formed to facilitate the raising of $15,000 for design and construction. A design and scale model by Portland artist Victor Schneider was selected and was placed on display at the Evergreen Hotel, but before the required funds could be raised the looming conflict in Europe diverted interest and Schneider's monument was never built. (Dale Denny collection.)

The Soviet ANT-25 was dismantled at Pearson Field and readied for shipment back to the Soviet Union. The plane is currently on display at the Monino Air Force Museum in Moscow. (Pearson Air Museum.)

Brig. Gen. George C. Marshall was the commander of the Vancouver Barracks when the Soviet Transpolar flight landed, and the recently appointed commander was thrust into the limelight. His diplomatic handling of the unexpected visit was recognized by his superiors, and even Marshall himself acknowledged later in life that the event proved to be a milestone in his career. He would later go on to serve as the army's chief of staff during World War II and, as secretary of state, is credited with the Marshall Plan to rebuild war-ravaged Europe. (Dale Denny collection.)

Sadly, Chkalov's reign as the Soviet's premier aviation hero would be short-lived. Eighteen months after his transpolar achievement, the Russian hero was dead, killed in a controversial test flight of a new Soviet fighter plane. Such was Chkalov's fame that both Joseph Stalin and his Prime Minister Vyacheslav Molotov served as pallbearers, although rumors persisted that the Soviet dictator might have played a role in the aviator's death. His remains were deposited in a place of honor in the Kremlin wall. (Pearson Air Museum.)

Chkalov and his companions became heroes in their homeland, with Chkalov acquiring the nickname "The Russian Lindberg." Such was his popularity that by year's end he was made a deputy of Soviet Nationalities and a member of the Supreme Soviet of the Soviet Union. Here he is pictured with his son Ivan and his wife Olga in a parade held in his honor. (Pearson Air Museum.)

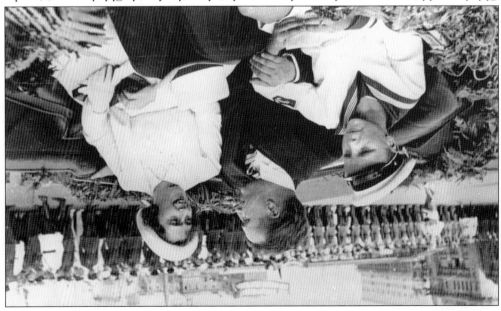

Six

THE COMMERCIAL FIELD

In this c. 1920 composite photograph, Portland photographer C. S. Woodruff envisioned the skies above his city filled with aircraft. (Pearson Air Museum.)

Civilian and commercial aviation grew dramatically at Pearson Field during the latter half of the 1920s and the early 1930s. In 1925, the Vancouver Chamber of Commerce leased 70 acres of land and established the Commercial Field. With the encouragement of base commander Oakley Kelly, the commercial side of the field, east of the military facilities, soon had its own row of hangars. (Pearson Air Museum.)

Arthur MacKenzie, of the MacKenzie and Goff Flying Aviation Company, is identified as the president of the Pearson Field Flying Club in 1925. The flying club was one of the organizations that assisted in preparations for the big air circus that accompanied the dedication of the newly named Pearson Field on September 16, 1925. The plane is a three-place American Eagle. (Oregon Historical Society, OrHi 66974.)

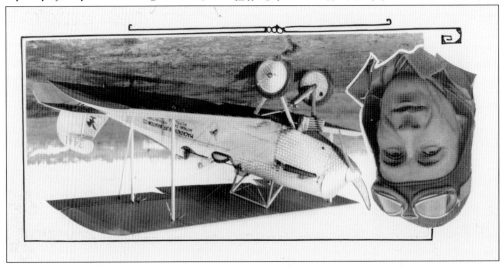

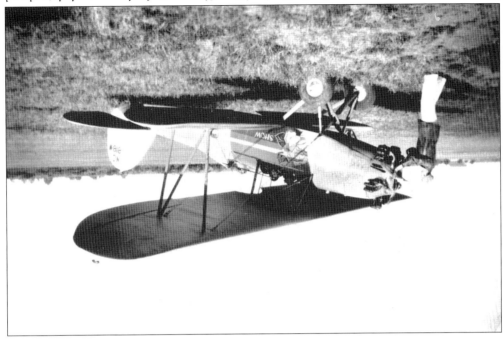

The Bush Flying Service operated out of the Commercial Field at Pearson. This Alexander Eaglerock biplane was used for flight instruction in 1926. (Pearson Air Museum.)

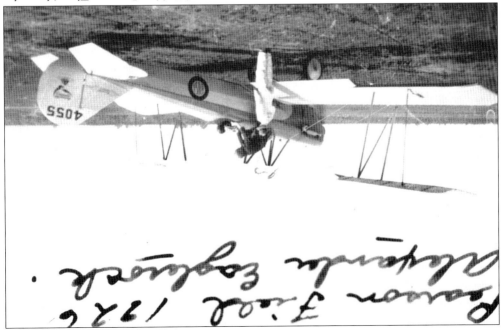

This plane, sporting a promotion for the Portland Rose Show on its fuselage, gets a helping hand in starting its motor. (Pearson Air Museum.)

This American Eagle biplane, powered by the OX-5 engine, belonged to Clarence Murray. The Shell Oil Company provided Murray with fuel in return for the advertising space on the plane. (Pearson Air Museum.)

Vance Breese was a demonstration pilot for Ryan Aircraft's new M-1 monoplane. He was so taken with the Pacific Northwest that he relocated in the mid-1920s. He would go on to have a long career as an aircraft designer and test pilot. (Pearson Air Museum.)

A New Ryan M-1 is pictured here at the Pearson Commercial Field in 1926. (Pearson Air Museum.)

The 1920s witnessed a dramatic growth in civil aviation at Pearson Field. Harold Rasmussen, owner of a stationary and radio shop on Vancouver's Main Street, was an aviation enthusiast and an influential member of the Vancouver Chamber of Commerce's aviation committee. He drew quite a crowd in 1928 when he parked a new Eaglerock A-4 biplane in the street in front of his shop. (Pearson Air Museum.)

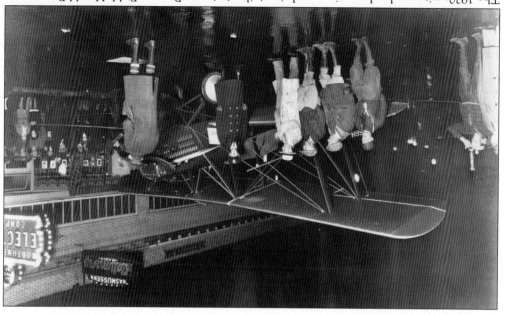

Claude Ryan visited Pearson Field in his M-1 mail plane while surveying the West Coast airmail route in 1926. In an impromptu race with Lt. Oakley Kelly, Ryan's sleek new M-1 monoplane beat Kelly's 1917 DH-4 in spite of the latter's advantage in horsepower. (Pearson Air Museum.)

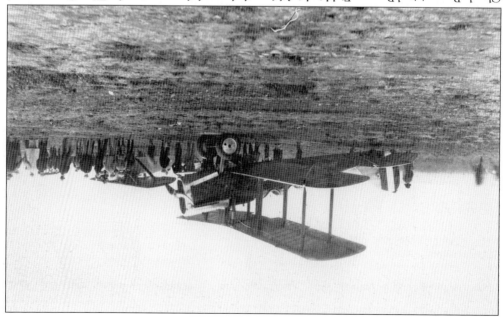

Lawrence "Hap" Roundtree earned his pilot's license in 1919 and operated a flying service at Pearson Field for many years. (Pearson Air Museum.)

This c. 1929 photograph depicts a pudgy-looking plane that was a one-of-a kind experimental aircraft built by the National Aircraft Corporation based at the Watts Airport in Beaverton, Oregon. The pilot sat outside behind a roomy enclosed passenger compartment, giving the plane its distinctive profile. It was nicknamed the "Flying Bath Tub" and the "Dill Pickle." (Pearson Air Museum.)

Pilots often offered rides in order to subsidize their own flying. This hangar at Pearson's Municipal Field offers flights for $10 and $15, presumably in the adjacent Curtiss "Jenny." (Pearson Air Museum.)

AIRPLANE PASSENGER FLIGHTS

An opportunity to see your city and surrounding country from the air.

Reserve Lieutenant N. B. Mamer will make passenger flights with his own three-passenger commercial plane from the Vancouver Air Field all day Saturday and Sunday. An exhibition of stunts and fancy flying will also be given.

Realize that cherished desire, come out and make a flight with a safe, experienced pilot.

No stunt unless requested by passenger.

Rate $5.00 Per Passenger

Vancouver Air Field

Reserve pilot N. B. Mamer, based in Spokane, augmented his military training by offering passenger flights and stunt exhibitions. Using his own plane at the Commercial Field, Mamer advertised $5-per-passenger flights, with stunts only upon request, in the April 12, 1924, issue of the *Vancouver Columbian*. (Vancouver National Historic Reserve Trust.)

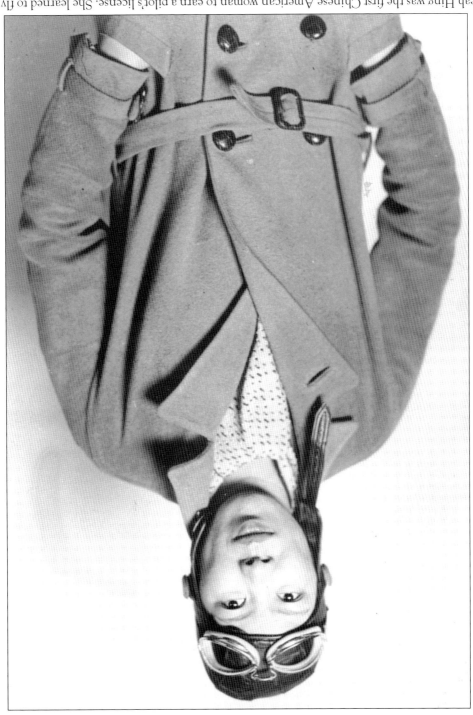

Leah Hing was the first Chinese American woman to earn a pilot's license. She learned to fly at Pearson Field under the tutelage of Tex Rankin and Pat Reynolds, a reserve officer with the 321st Observation Squadron. She paid for her lessons from wages earned at her father's restaurant, the Tea Garden. Hing's 1932 Fleet biplane is now on display at the Pearson Air Museum. (Oregon Historical Society, OrHi 58757.)

Bookwalter was in the lead for his class of entrants when the planes landed in Medford, Oregon. While flying low through dense fog over the mountains south of Eugene, however, the *City of Vancouver's* engine failed and Bookwalter crashed. Bookwalter escaped injury and wandered through the woods for 24 hours before reaching Eugene. The *City of Vancouver* was a total wreck. (Pearson Air Museum.)

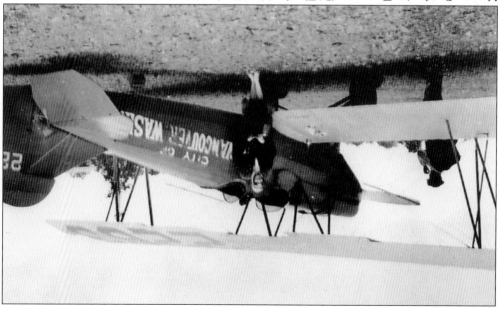

Veteran Pacific Air Transport (PAT) pilot Vern Bookwalter entered his Travel Air in the San Francisco to Spokane Air Race, held in conjunction with the National Air Races of 1927. He agreed to allow the local chamber of commerce to adopt his plane, and they painted the name *City of Vancouver* on the sides in large letters. (Pearson Air Museum.)

Vancouver celebrated its centennial in 1925 with the production of a commemorative 50¢ piece by the U.S. Mint in San Francisco. Lt. Oakley Kelly and *Oregon Journal* managing editor Don Sterling made a record-setting flight from Pearson to San Francisco and back in 10 hours and 55 minutes to retrieve the shipment of 50,000 coins. *Vancouver Columbian* publisher Herbert Campbell hands the first coin minted to mayor N. E. Allen for delivery to President Calvin Coolidge. Pictured, from left to right, are Herbert Campbell, Oakley Kelly, Mayor Allen, Howard Warren, and an unidentified guard. (Oregon Historical Society, OrHi 38814.)

An unidentified man poses by his airplane at the commercial field around 1928. (Pearson Air Museum.)

This *c.* 1928 photograph depicts a Ryan Brougham at the commercial section of Pearson Field. It was owned and operated by the Hans Mirow Flying Service of Portland. (Pearson Air Museum.)

A Consolidated Fleet biplane with a Kinner engine is pictured at Pearson Field around 1930. The headquarters of the 321st Observation Squadron, now part of the Vancouver National Historic Reserve, is in the background. Consolidated Fleet aircraft were named for Reuben Fleet, a Consolidated executive and native of Washington State. (Pearson Air Museum.)

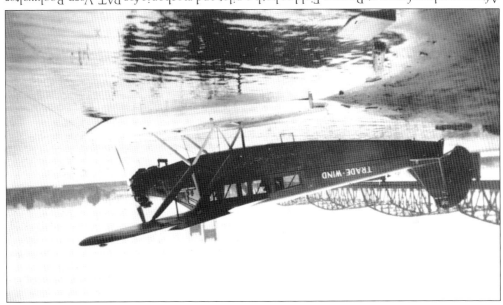

After a number of years at Pearson Field as both a pilot and mechanic for PAT, Vern Bookwalter decided to move on. He purchased this Travel Air cabin plane and fitted it with pontoons prior to leaving for Lake Coeur D'Alene in Idaho. He would later go on to fly in Alaska. Bookwalter's plane is pictured here on the southern bank of the Columbia River near the Interstate Bridge. (Pearson Air Museum.)

Mrs. Oakley Kelly wishes bon voyage to 93-year-old Ezra Meeker on October 1, 1924. Meeker had come west by wagon over the Oregon Trail in 1852. In 1906, at the age of 76, Meeker packed up his old Saratoga wagon and retraced his route across the country to generate support for marking and preserving the old Oregon Trail. This trip was so successful that the pioneer repeated his trip in 1910. In 1924, Meeker rode as a passenger with Lt. Oakley Kelly over much of the old trail, from Pearson Field to Dayton, Ohio. Every hour of flight corresponded to a week's journey on his previous trips. Prior to taking off with Kelly, Meeker removed his dentures and placed them in his pocket for safekeeping. (Oregon Historical Society CN009277.)

A Fairchild 24, a Luscombe, a Ryan PT-22, a J-3 Cub, a J-5 Cub, a Monocoupe, and a Stinson rest at the commercial field. The Fairchild and J-3 belonged to the Vancouver Flying Service, owned and operated by Don and Phil Blair. (Pearson Air Museum.)

This unidentified man poses next to his airplane at the commercial field c. 1930. (Pearson Air Museum.)

This Stearman Speedmail attracts the attention of the crowd at Pearson Field, possibly during the Pacific Northwest Air Tour of 1930. (Pearson Air Museum.)

The first Pacific Northwest Air Tour selected Pearson Filed as the starting point for their journey on July 28, 1930.The participating planes are lined up for exhibition along the edge of the field. (Dale Denny collection.)

The City of Vancouver replaced the chamber of commerce as the operator of the commercial field in 1929. The following year, the newly improved municipal field was dedicated with an air show attended by thousands. The committee of civic and aviation leaders responsible for the celebration pose in front of an Alexander Eaglerock biplane. Pictured, from left to right, are (first row) Bert Justin, Charles Mears, Freddie Sauers, Art Whitaker, Sid Monastes, unidentified, Fred Rafferty; and (second row) Henry Rasmussen, Ed Klysner, Led Boyd, Edith Foltz, Major Gilbert Eckerson, J. L. "Dad" Bacon, and Lt. Carlton Bond.

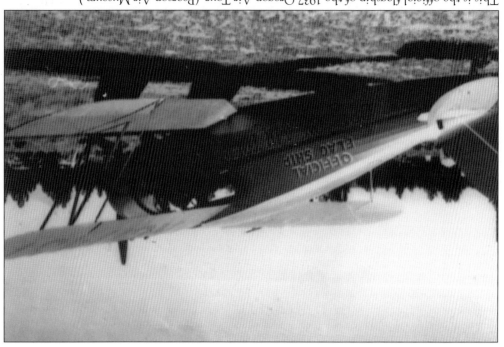

This is the official flagship of the 1937 Oregon Air Tour. (Pearson Air Museum.)

This diminutive *Little Eagle* was one of several homemade aircraft that found their way to Pearson Field in the period between the world wars. Pearson's wide expanse of graded-grass runways made it an ideal location for the testing of homemade and experimental aircraft. (Pearson Air Museum.)

This is a souvenir airmail letter from the Pacific Northwest Air Tour at Pearson Field on July 29, 1930. This letter, with its special cachet, was carried aloft in one of the tour's planes. Pearson Field was selected to serve as the starting point for this air tour of Pacific Northwest cities. (Pearson Air Museum.)

A Vancouver police officer is among the many on the field watching as planes of the 1930 Pacific Northwest Air Tour arrive. (Dale Denny collection.)

Local aviator Art Bohrer and his Alexander Eaglerock biplane are pictured here around 1928.

An Alexander Eaglerock biplane sits at the Pearson Commercial Field c. 1928. The forward cockpit on the Eaglerock was large enough to accommodate two passengers. In the background can be seen the aircraft of the 321st Observation Squadron on the military side of the field. (Pearson Air Museum.)

A Waco KNF, owned by James L. "Dad" Bacon, is pictured here around 1936. Bacon was a longtime fixture at Pearson Field, providing much of the commercial field's services for many years. His hangar served as an unofficial center for activity at the field. (Pearson Air Museum.)

A small crowd gathers around a Student Prince biplane at the commercial section of Pearson Field. In 1929, students at Portland's Adcox Aviation Trade School built a prototype plane and in 1930 manufactured six under the name Student Prince. (Pearson Air Museum.)

The first to actually fly this odd new plane was Portland aviator and daredevil Danny Grecco. On August 4, 1937, Grecco was able to get the plane off the ground, but it refused to bank and turn, resulting in a forced landing. A second attempt to fly the craft, known as the JX-5, the following spring, with Sidney Monastes at the controls, resulted in the plane plowing into a fence at the end of the runway. No further attempts to fly the JX-5 were ever made. (Pearson Air Museum.)

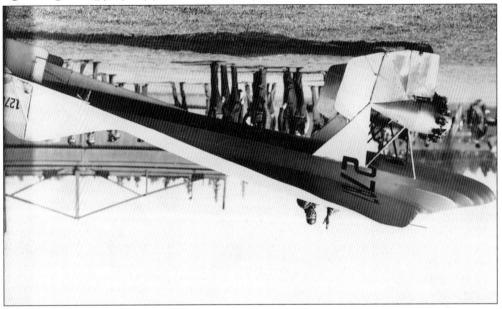

This 1930s photograph shows, from left to right, Ernie Christiansen, L. C. "Hap" Roundtree, and Al Greenwood with an Alexander Eaglerock plane. Roundtree and Greenwood both operated flying services at Pearson's Municipal Field.

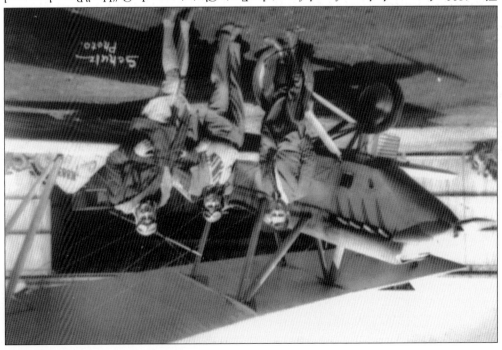

The open space of Pearson Field proved especially attractive to those wishing to test fly homemade and experimental aircraft. This unconventional-looking airplane made its appearance in 1937 and quickly earned a number of nicknames, including "The Flying Pancake," "The Flying Fuselage," and "The Flying Pumpkinseed." To its designers and builders, Lyle and Ervin Joy, however, the plane was known as the JX-5. When rolled out for a test flight it drew quite a crowd. (Dale Denny collection.)

In place of traditional wings, the JX-5's wood and fabric fuselage was flattened out like a cobra's head. The twin 38-horsepower Salmson engines were mounted below the fuselage on the wheel struts. It was the Joy's belief that such a configuration would "provide more lift with less horsepower." The first attempt to fly the airplane was in 1937, with Danny Grecco at the controls. This flight proved unsuccessful. (Dale Denny collection.)

In 1938, a second attempt was made to fly the JX-5, this time with Sid Monastes as pilot. The airplane roared down the grass runway but failed to lift off the ground. At the end of the field, the plane caught on a barbed wire fence and nosed into the ground, collapsing the nose and breaking the propellers. In this photograph, Sid Monastes, with his parachute over his shoulder, mingles with the curious spectators. (Dale Denny collection.)

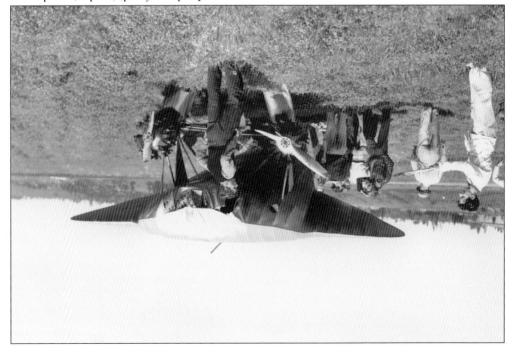

Seven

PACIFIC AIR TRANSPORT

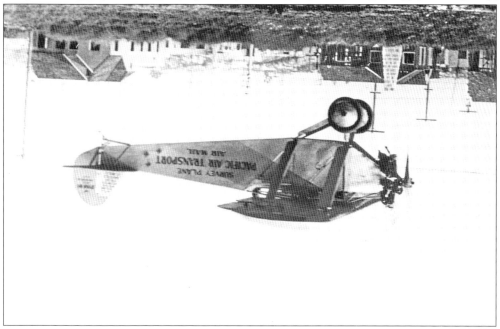

Vern Gorst and Claude Ryan leave San Diego in the Pacific Air Transport (PAT) survey plane, a Ryan M-1, in 1926. Written on the plane's tail are the names of all the cities and towns selected as terminals for Contract Air Mail Route 8. Although Portland is among those listed, that city's airmail service was actually based at Pearson Field. (Southern Oregon Historical Society, No. 959.)

Vern Gorst, founder of PAT, and Claude Ryan, of the Ryan Aircraft Company, made an aerial survey for the recently awarded Contract Air Mail Route 8 (CAM 8) in early 1926. Gorst selected Ryan's M-1 monoplane as a major component of his fleet. (Southern Oregon Historical Society, No. 23570.)

Vern Gorst confers with Portland, Oregon, postmaster J. M. Jones at Pearson Field on March 20, 1926. The aircraft is the Ryan M-1 Pacific Air Transport survey plane. (Oregon Historical Society, OrHi 105639.)

Seen here in 1927 is veteran PAT mail pilot and mechanic Vernon Bookwalter. Bookwalter's flight certificate, forerunner of the modern pilot's license, was number 82 and was signed by Orville Wright. (Pearson Air Museum.)

N. B. Evans, Pacific Air Transport president Vern Gorst, PAT vice president A.K. Humphries, and Charles Piper pose beside one of PAT's cabin ships. Under Gorst's ownership, Pacific Air Transport remained seriously under-financed and his pilots were often paid with stock. In late 1927, Gorst sold PAT to Boeing Air Transport, which continued to operate the line under its original name. (Oregon Historical Society, OrHi 105638.)

Jack Evans, Portland postmaster J. M. Jones, Grover Tyler, and Vernon Bookwalter load mail onto a PAT M-1 mail plane on September 15, 1926, inaugurating airmail service on the West Coast. Since the first airmail flight out of Pearson left before dawn, the ceremonies marking the event actually took place later in the day, after the return flight from Medford, Oregon. (Oregon Historical Society, CN 000350.)

Art Starbuck was one of the original Pacific Air Transport airmail pilots, usually flying between Medford, Oregon, and San Francisco. He was killed in 1931 when, encountering heavy fog, he crashed nine miles from the Burbank, California, airport. (Oregon Historical Society, 1288.)

A group of mechanics work on the engine of a Ryan B-1 Brougham, belonging to Pacific Air Transport, around 1928. The B-1 was one of many different aircraft used by PAT. A modified version of the Ryan was selected by Charles Lindbergh for his solo flight across the Atlantic in 1927. (Dale Denny collection.)

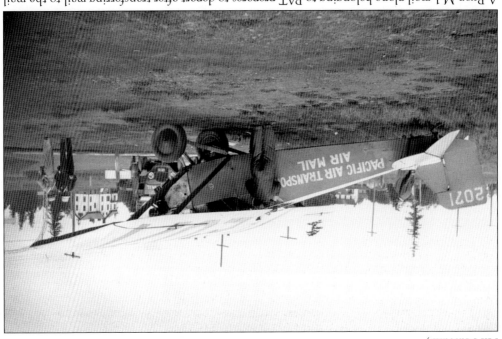

A Ryan M-1 mail plane belonging to PAT prepares to depart after transferring mail to the mail truck in the background around 1926. (Dale Denny collection.)

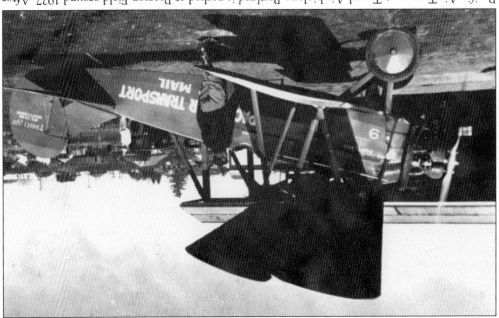

Pacific Air Transport Travel Air biplane *Portland* is parked at Pearson Field around 1927. After PAT merged with Boeing Air Transport in late 1927, a new company, consisting of Boeing Air Transport, Boeing Aircraft, and Pacific Air Transport, was formed under the new name Boeing Airplane and Transport Corporation. When aircraft engine manufacturer Pratt and Whitney was added, the holding company was reorganized as United Aircraft and Transport. In 1930, National and Varney Airlines would be added to the mix to create United Airlines. (Pearson Air Museum.)

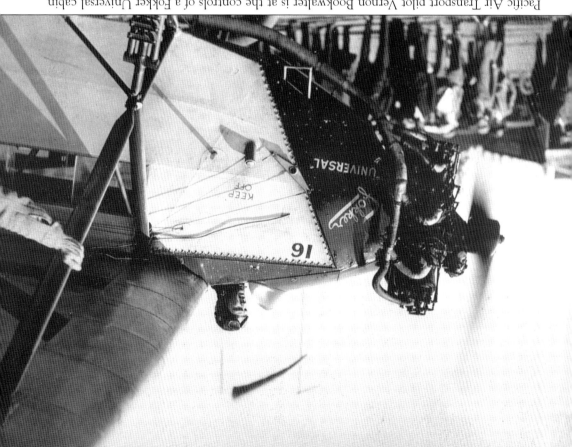

Pacific Air Transport pilot Vernon Bookwalter is at the controls of a Fokker Universal cabin plane. The Universal was the first commercial aircraft designed and manufactured by Fokker's United States plant, known as the Atlantic Aircraft Corporation. The plane was designed to carry either passengers or freight and had wood wings and a fabric-covered steel tube fuselage. Of the 45 Universals manufactured, almost half saw service in Canada's back country. (Pearson Air Museum.)

As passenger service began competing with mail for space on the planes, Pacific Air Transport, now owned by Boeing Air Transport, introduced new, larger aircraft with enclosed cabin space for up to four people, specifically the Boeing B-40. This particular B-40, named the *City of San Francisco*, carries the insignia of Boeing Air Transport. (Pearson Air Museum.)

In February 1934, Postmaster General James Farley canceled all of the private mail contracts, citing alleged collusion amongst the carriers. Delivery of airmail was transferred to army pilots by order of Pres. Franklin D. Roosevelt. Unused to the unique nature of airmail delivery, army pilots suffered such a large number of accidents that the president was forced to suspend all airmail flying in March. During this period, several Douglas O-25 mail planes were based out of Pearson Field. (Pearson Air Museum.)

Eight

BARNSTORMERS AND PARACHUTE JUMPERS

Wing walking was one of the more extreme barnstorming stunts, providing heart-stopping thrills for the crowds below. Tex Rankin employed a number of wing walkers, including Danny Grecco and a couple of the young ladies who performed stunts to pay for their flying lessons. In 1936, the federal government prohibited wing walking below 1,500 feet and required the use of a parachute. With it relegated to altitudes too high for the spectators to see well, and the anticipated danger negated by parachutes, wing walking soon lost much of its appeal. (Pearson Air Museum.)

Tex Rankin, who operated one of the nation's largest flying schools out of Pearson Field and later Portland's Swan Island Airport, was an enthusiastic supporter of aerial exhibitions, which he saw as a way to promote aviation and generate an interest in his flying school. His exploits in the air soon became the stuff of legend. He is seen here with his brothers Dick and Dudley by their Waco biplane around 1924. (Pearson Air Museum.)

Aviation was a major attraction for crowds and the media throughout the Roaring Twenties. These two cameramen are at Pearson Field, perhaps to film the stunt flying of either Danny Grecco or Tex Rankin. (Pearson Air Museum.)

One of Danny Grecco's more popular stunts was to transfer from one airplane to another, in flight and without a parachute, to the great delight of the crowds below. Grecco began performing these stunts to pay for his flight training. (Pearson Air Museum.)

Dick Rankin was one of Tex Rankin's brothers and himself a pilot and instructor with the Rankin Flying School. He is pictured here beside the Rankin's Waco biplane. (Pearson Air Museum.)

Danny Grecco poses in his Great Lakes biplane c. 1930. The Great Lakes was an agile little aircraft popular with aerobatic pilots in the late 1920s and early 1930s. (Pearson Air Museum.)

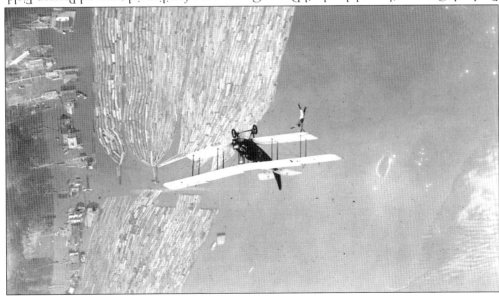

Portland, Oregon, pilot and daredevil Danny Grecco was a familiar sight around Pearson Field. He is pictured here hanging from the wing of a Curtiss "Jenny" over the Columbia River c. 1928. (Pearson Air Museum.)

Danny Grecco was a familiar sight at Pearson Field. He assisted with Silas Christofferson's 1912 flight from the Multnomah Hotel, performed stunts with the Rankin Air Circus, and was himself a skilled pilot and mechanic. He is pictured here in 1928 with his three-place Avro biplane. (Pearson Air Museum.)

Dorothy Hester enrolled in the Rankin Flying School in 1927 and so impressed her instructors that she soon became Tex Rankin's protégé. She quickly established herself as the nation's top female acrobatic pilot, and her world record of 69 continuous loops was held for 58 years. (Pearson Air Museum.)

Ann "Half-Pint" Bohrer, Dorothy Hester, and Fay "Tiny" Carter prepare to make their parachute jumps with the Tex Rankin Air Circus around 1929. Rankin frequently held such shows to promote aviation in general and his flying school in particular. (Pearson Air Museum.)

Anne "Half Pint" Bohrer and Tex Rankin prepare to take off for a parachute jump exhibition around 1929. Bohrer later recalled that on her first jump she froze on the wing and Rankin had to rap her on the knuckles with his fire extinguisher to get her to release her grip. (Pearson Air Museum.)

Dorothy Hester, bundled up in her flight suit, and three unidentified men pose by Tex Rankin's Stinson Detroiter c. 1930. On the right is John "Tex" Rankin. (Pearson Air Museum.)

Ann Bohrer was nicknamed "Half Pint" as a student at Tex Rankin's flying school. In order to pay for her instruction, she took a job as Tex's personal secretary. She also agreed to perform parachute jumps at Rankin's many demonstrations. (Pearson Air Museum.)

Edith Foltz was one of several women to take to the skies from Pearson Field. She was selected as queen of the air show at the 1930 dedication of the Pearson Municipal Airport. In 1929, she finished second in the first women's cross-country air race, dubbed the Powder-puff Derby by humorist Will Rogers. During World War II, Foltz volunteered for the Air Transport Auxiliary, ferrying aircraft from the factories to the front. For her efforts she was awarded the King's Medal. (Pearson Air Museum.)

Tex Rankin shakes hands with Oakley Kelly as Dudley and Dick Rankin stand by. The plane, a Stinson Detroiter named *On to Oregon*, is being readied for an attempt to set a new flight-refueling endurance record in 1930 in the skies above Pearson Field and Portland. The Rankins began their flight on August 17, but an air lock in the refueling hose forced them to abandon their efforts after 24 hours. (Pearson Air Museum.)

Nine

PEARSON AIRPARK

Pearson Field's proximity to the Columbia River is clear in this aerial photograph taken shortly after World War II. In the center of the photograph is the Kaiser Shipyard, which produced many ships for the war effort. Mount Hood looms in the background. (Pearson Air Museum.)

After World War II, with the ban on non-military flying lifted, civil aviation returned to Pearson Field. In 1949, the army turned over its portion of the field to the city. With visions of a greatly expanded postwar airfield, this merger of the commercial and military fields was renamed Pearson Airpark. (Pearson Air Museum.)

By 1989, Pearson Airpark had become a bustling general aviation center. This led to increasing tensions with the National Park Service, which operated the adjacent reconstruction of Fort Vancouver. In a cooperative venture, the two rows of hangars next to the fort were later razed to create a buffer between the fort and flight operations. (City of Vancouver.)

When this aerial photograph was taken in 1985, it is clear that the growth of Pearson Field and the reconstruction of the Fort Vancouver stockade would put the airport and the National Park Service on a collision course. Eventually, however, a compromise was reached between the two parties. Pearson's operations were relocated farther away from the stockade and the adjacent hangars removed to create a visual buffer around the National Park Service site. (City of Vancouver.)

Today Pearson Field continues to be operated by the City of Vancouver. It is a full-service general aviation facility with paved runways and is home to an estimated 175 aircraft. On an average day, an estimated 220 planes use the field. (City of Vancouver.)

The original design for a monument to Valery Chkalov and the transpolar flight of 1937 was never built, but the idea never fully disappeared. In 1975, a new monument to the historic Soviet flight was dedicated on the south side of the field. The two surviving members of the crew, Alexander Belyakov and Georgi Baidukov, both now generals, were present at the ceremony. The monument was later relocated to its present site, adjacent to the Jack Murdock Aviation Center, placing it very near the actual spot where the flight ended. (Dale Denny collection.)

In 1994, the M. J. Murdock Charitable Trust awarded a $3 million grant for the construction of a new museum building on the site of the hangar that burned in 1976. The new structure, which incorporated the smaller historic hangar, was designed to recreate the look of a typical army air base of the interwar period. This modern museum is home to the Pearson Air Museum. In the center of the photograph is the relocated Chkalov transpolar monument. (Pearson Air Museum.)

This statue of Carlton Bond welcomes visitors to the Pearson Air Museum's Jack Murdock Aviation Center. Bond served as the commanding officer at Pearson from 1929 through 1933 and again from 1938 through 1940. After his retirement, Bond returned to Vancouver to live out his life. He died in 1980. (Author's collection.)

The headquarters building of the 321st Observation Squadron was originally the office of the spruce mill constructed during World War I and was moved to its present location in the late 1920s. The structure still stands today, part of the Pearson Air Museum complex. In the foreground is a DC-3. (Author's collection.)

On September 19, 2005, Pearson Field celebrated the centennial of Lincoln Beachey's flight from Portland's Lewis and Clark Centennial Exposition and the 80th anniversary of the naming of the field in honor of Lt. Alexander Pearson. In a ceremony that praised the past achievements, Pearson Field embarked on its second century of service to the community. (Author's collection.)

ACROSS AMERICA, PEOPLE ARE DISCOVERING
SOMETHING WONDERFUL. THEIR HERITAGE.

Arcadia Publishing is the leading local history publisher in the United States. With more than 3,000 titles in print and hundreds of new titles released every year, Arcadia has extensive specialized experience chronicling the history of communities and celebrating America's hidden stories, bringing to life the people, places, and events from the past. To discover the history of other communities across the nation, please visit:

www.arcadiapublishing.com

Customized search tools allow you to find regional history books about the town where you grew up, the cities where your friends and family live, the town where your parents met, or even that retirement spot you've been dreaming about.